Introduction

KODAK COLOR *DATAGUIDE*

In recent years, color photography has mushroomed to include a large number of color films and papers.

These products permit color photography under almost unlimited conditions.

Several processing methods permit either standard results or special effects.

The final picture can appear as a color slide, a large color transparency, a color print, or a black-and-white print.

Such photographic versatility as this has its drawbacks, however. As the number of products and processes increases, the amount of practical information on how to use them grows, too. That practical information for all Kodak color

products and processes has been collected, condensed, organized, and clearly presented in this KODAK Color DATAGUIDE. In this tidy package is all the basic information you need to correctly expose, process, and print color pictures. Here are easy-to-use computers that do the figuring for you. Here are helpful devices — such as a standard negative, a sample color print, and a set of viewing filters — which help you get better color prints quickly and economically.

Purposely, all theory and extensive explanation have been omitted. In this reference book, the material is limited to basic descriptive and working data. Photographers who want more complete background information should consult the Kodak publications mentioned on page 44.

This 1975 printing contains data on new KODAK VERICOLOR II Professional, KODACHROME 25, and KODACHROME 64 Films. Kodak Ektaprint RD chemicals have been re-named Kodak Ektaprint R-500 chemicals.

Standard Book Number 0-87985-086-8
© Eastman Kodak Company, 1974

FIFTH EDITION—Second Printing, 1975

PATHWAYS TO COLOR

With KODAK Reversal Materials

CAMERA FILMS

KODACHROME II Professional (Type A)

KODACHROME 25 (Daylight)

KODACHROME 64 (Daylight)

EKTACHROME-X

High Speed EKTACHROME (Daylight and Tungsten)

EKTACHROME Professional (Daylight and Type B)

With KODAK Negative-Positive Materials

CAMERA FILMS

KODACOLOR II

EKTACOLOR Professional (Types S and L)

VERICOLOR II Professional (Types S and L)

INTERNEGATIVE FILMS

EKTACOLOR Internegative 6110 (sheets)

EKTACOLOR Internegative 6008 (long rolls)

REFLECTION PRINTS

EKTACHROME RC Paper, Type 1993

Dye Transfer Paper*

TRANSPARENCY DUPES

EKTACHROME Slide Duplicating Film 5038 (Process E-4) (long rolls)

EKTACHROME Duplicating Film 6120 (Process E-3) (sheets)

DAY-NIGHT PRINTS

Dye Transfer Film 4151 (ESTAR Thick Base) (sheet)*

REFLECTION PRINTS

EKTACOLOR 37 RC Paper

Dye Transfer Paper*

PANALURE Paper (for black-and-white prints)

TRANSPARENCIES

EKTACOLOR Slide Film 5028 (long rolls)

EKTACOLOR Print Film 4109 (ESTAR Thick Base) (sheets)

DAY-NIGHT PRINTS

Dye Transfer Film 4151 (ESTAR Thick Base) (sheet)*

*Printing from transparencies requires color-separation negatives on KODAK SUPER-XX Pan Film 4142 (ESTAR Thick Base) and matrices on KODAK Matrix Film 4150 (ESTAR Thick Base), or equivalent. Printing from color negatives requires matrices on KODAK Pan Matrix Film 4149 (ESTAR Thick Base), or equivalent. Prints on KODAK Dye Transfer Film 4151 can be viewed by either reflected light or a combination of reflected and transmitted light.

Contents

FILMS DATA

EXPOSURE CORRECTIONS

FILTERS

GRAY CARD
GRAY SCALE

PROCESSING DATA

PROCESS STEPS

REPLENISHMENT

CAPACITIES

FILTER CHART

VIEWING FILTERS

FILTER COMPUTER

PRINT COMPUTER

KODAK FILM NAME AND TYPE	CHEMICALS	SHEET-FILM CODE NOTCH OR ROLL-FILM SIZES AVAILABLE	DESCRIPTION	DAYLIGHT SPEED WITH SUGGESTED FILTER[4]
EKTACOLOR Professional S	C-22		Color negative sheet film for short exposure times (1/10 second or shorter). Roll sizes CPS120, 620, 220, 135-36.	100 No Filter
VERICOLOR II Professional S	C-41		Color negative sheet film for short exposure times (1/10 second or shorter). Roll sizes VPS120, 620, 220, 135-20, 135-36.	100 No Filter
EKTACOLOR Professional L	C-22		Color negative sheet films for long exposure times. Roll size VPL120.	64 (1/10 sec) No. 85B
VERICOLOR II Professional L	C-41		Color negative sheet films for long exposure times. Roll size VPL120.	50 (1/50 sec) No. 85B
KODACOLOR II	C-41	C110, 126, 135, 127, 828, 116, 120, 620	Color negative film for exposure with daylight, blue flash, or electronic flash.	80 No Filter
EKTACHROME Daylight (E-3)	E-3		Color transparency sheet film for exposure with daylight, blue flash, or electronic flash. Available in EP120 rolls also.	50 No Filter
EKTACHROME B (E-3)	E-3		Color transparency sheet film for exposure with tungsten illumination. Available in EPB120 rolls also.	25 No. 85B
High Speed EKTACHROME (Daylight)	E-4	EH126, 135, and 120	Color transparency film for exposure with available daylight illumination.	160 No Filter
High Speed EKTACHROME (Tungsten)	E-4	EHB135 and 120	Color transparency film for exposure with available tungsten illumination.	80 No. 85B
EKTACHROME-X	E-4	EX110, 126, 135, and other size rolls	Color transparency film for exposure with daylight, blue flash, or electronic flash.	64 No Filter
KODACHROME 25 (Daylight)	No Kits	KM135 and 828	Color transparency film for exposure with daylight, blue flash, or electronic flash.	25 No Filter
KODACHROME II Professional A	No Kits	KPA135-36	Color transparency film for exposure with tungsten (photoflood) illumination.	25 No. 85
KODACHROME 64 (Daylight)	No Kits	KR110, 126, and 135	Color transparency film for exposure with daylight, blue flash, or electronic flash.	64 No Filter

1. KODAK EKTACOLOR Professional Films are expected to be discontinued in 1975. KODAK VERICOLOR II Professional Films will supersede them.
2. These tables are intended as starting points in determining the correct guide number. They are based on the use of the KODAK WRATTEN Filters specified. The tables are for use with equipment rated in beam candlepower-seconds (BCPS) or effective candlepower-seconds (ECPS). Divide the proper guide number by the flash-to-subject distance in feet to determine the lens opening for average subjects.
3. The values in these tables are for use with bowl-shaped polished reflectors. If shallow, cylindrical reflectors are used, divide guide numbers by 2. The values are based on the use of the KODAK WRATTEN Filters specified. Divide the guide number by the bulb-to-subject distance in feet to determine the lens opening for average subjects. Use ½ stop larger for dark subjects; ½ stop smaller for light subjects. Use a flashguard over the reflector. Do not flash bulbs in an explosive atmosphere.

GUIDE NUMBER FOR TRIAL

OUTPUT OF UNIT (BCPS or ECPS)									
350	500	700	1000	1400	2000	2800	4000	5600	8000

No Filter Required

350	500	700	1000	1400	2000	2800	4000	5600	8000
40	50	60	70	85	100	120	140	170	200

At shutter speeds longer than 1/50 sec, results may be influenced by other illumination.

Not Recommended

No filter required. However, if prints are consistently bluish, use a KODAK WRATTEN Filter No. 81B and increase exposure ⅓ stop

35	45	55	65	75	90	110	130	150	180

For filter suggestion, see supplementary data sheet packaged with film.

30	35	40	50	60	70	85	100	120	140

At shutter speeds longer than 1/50 sec, results may be influenced by other illumination.

Not Recommended

No Filter Required

55	65	75	90	110	130	150	180	210	250

With KODAK WRATTEN Filter No. 85B

35	45	55	65	75	90	110	130	150	180

No Filter Required

32	40	45	55	65	80	95	110	130	160

No Filter Required

20	24	30	35	40	50	60	70	85	100

Not Recommended

No Filter Required

32	40	45	55	65	80	95	110	130	160

FLASH EXPOSURE GUIDE NUMBERS[3]

FILTER REQUIRED (None, if blue bulbs are used with Daylight Film)	BETWEEN-THE-LENS SHUTTER SPEED	SYNCHRONIZATION M			NO. 3 OR 50 IN 12-INCH BOWL REFLECTOR (Use 1/25 or slower)	FOCAL-PLANE SHUTTER SPEED	FP FLASH-BULBS
		AG-1(B)*	M3(B)† 5(B)‡ 25(B)‡	11§ 40§			6(B)‡ 26(B)‡
				2(B)§ 22(B)§			
80D with clear AG-1, M3 80C with all other clear bulbs	1/25-1/30 1/50-1/60 1/100-1/125 1/200-1/250	90 90 75 65	170 160 130 110	220 200 180 130 / 210 200 170 130	320	1/60 1/125 1/250 1/500	180 130 85 60
			Not Recommended				
80D with clear AG-1, M3 80C with all other clear bulbs	1/25-1/30 1/50-1/60 1/100-1/125 1/200-1/250	80 80 70 55	150 140 120 90	140 130 110 85 / 200 180 150 110	260	1/60 1/125 1/250 1/500	120 75 55 38
80D with clear AG-1, M3 80C with all other clear bulbs	1/25-1/30 1/50-1/60 1/100-1/125 1/200-1/250	70 70 60 50	130 120 100 85	130 120 100 80 / 170 160 130 100	230	1/60 1/125 1/250 1/500	100 70 50 34
81C with clear bulbs only	1/25-1/30 1/50-1/60 1/100-1/125 1/200-1/250	60 60 50 40	120 110 80 75	130 120 100 80 / 160 150 130 100	250	1/60 1/125 1/250 1/500	95 70 50 34
80D with clear AG-1, M3 80C with all other clear bulbs	1/25-1/30 1/50-1/60 1/100-1/125 1/200-1/250	130 130 110 90	240 220 190 150	230 210 190 140 / 300 280 240 180	500	1/60 1/125 1/250 1/500	180 120 90 60
81C with clear bulbs only	1/25-1/30 1/50-1/60 1/100-1/125 1/200-1/250	120 120 100 80	250 220 190 150	260 240 210 160 / 320 310 260 200	475	1/60 1/125 1/250 1/500	190 130 95 65
80D with clear AG-1, M3 80C with all other clear bulbs	1/25-1/30 1/50-1/60 1/100-1/125 1/200-1/250	75 70 60 50	130 120 110 85	120 120 100 75 / 160 150 130 100	240	1/60 1/125 1/250 1/500	100 70 50 34
80D with clear AG-1, M3 80C with all other clear bulbs	1/25-1/30 1/50-1/60 1/100-1/125 1/200-1/250	45 45 38 32	85 80 65 55	75 70 45 45 / 100 90 80 60	150	1/60 1/125 1/250 1/500	65 42 30 22
81C with clear bulbs only	1/25-1/30 1/50-1/60 1/100-1/125 1/200-1/250	65 65 55 45	140 130 90 85	150 130 120 90 / 180 170 140 110	260	1/60 1/125 1/250 1/500	105 80 55 38
80D with clear AG-1, M3 80C with all other clear bulbs	1/25-1/30 1/50-1/60 1/100-1/125 1/200-1/250	75 70 60 50	130 120 110 85	120 120 100 75 / 160 150 130 100	240	1/60 1/125 1/250 1/500	100 70 50 34

Bowl-shaped polished reflectors: *2-inch; †3-inch; ‡4- to 5-inch; §6- to 7-inch

PHOTOLAMP (3400 K) SPEED WITH SUGGESTED FILTER[4]	TUNGSTEN (3200 K) SPEED WITH SUGGESTED FILTER[4]	EXPOSURE[5] AND FILTER COMPENSATION FOR RECIPROCITY CHARACTERISTICS[6] Exposure Time (Seconds)						KODAK FILM NAME AND TYPE
		1/1000	1/100	1/10	1	10	100	
32 No. 80B	25 No. 80A	None No Filter	None No Filter	None No Filter	Not Recommended			EKTACOLOR Professional S / VERICOLOR II Professional S
64 (for 1-second exposure) No. 81A	64 (for 5-second exposure) No Filter	Not Recommended		No Filter from 1/10 to 60 seconds				EKTACOLOR Professional L
50 (for 1-second exposure) No. 81A	50 (for 5-second exposure) No Filter	Not Recommended		(See Note 7 below)				VERICOLOR II Professional L
25 No. 80B	20 No. 80A	None No Filter	None No Filter	None No Filter	+½ stop No Filter	+1½ stops CC10Y	+2 stops CC10Y	KODACOLOR II
Not Recommended	Not Recommended	None No Filter	None No Filter	+½ stop CC10B	+1 stop CC10B	+2 stops CC10B +CC10M	Not Rec.	EKTACHROME Daylight (E-3)
25 No. 81A	32 No Filter	None No Filter	None No Filter	None No Filter	None No Filter	(See Note 8 below)		EKTACHROME B (E-3)
50 No. 80B	40 No. 80A	None No Filter	None No Filter	None No Filter	+1 stop No Filter	+1½ stops No Filter	Not Rec.	High Speed EKTACHROME (Daylight)
100 No. 81A	125 No Filter	None No Filter	None No Filter	None No Filter	None No Filter	+1 stop No Filter	Not Rec.	High Speed EKTACHROME (Tungsten)
20 No. 80B	16 No. 80A	None No Filter	None No Filter	None No Filter	+1 stop No Filter	+2 stops CC15Y	Not Rec.	EKTACHROME-X
8 No. 80B	6 No. 80A	Request current data from Department 841, Rochester, N.Y. 14650.						KODACHROME 25 (Daylight)
40 No Filter	32 No. 82A	None No Filter	None No Filter	+½ stop No Filter	+½ stop No Filter	+1 stop CC10Y	Not Rec.	KODACHROME II Professional A
20 No. 80B	16 No. 80A	Request current data from Department 841, Rochester, N.Y. 14650.						KODACHROME 64 (Daylight)

4. The film speeds given are based on an ANSI Standard and are for use with meters and cameras marked for ASA speeds. The settings apply to reflected- or incident-light readings of average subjects. Consult camera manual if camera has a through-the-lens exposure meter.

5. The exposure increase includes the adjustment required by any filter or filters suggested.

6. The data for each film apply only to the type of illumination for which that film is balanced, and the figures are based on average emulsions.

7. Set the meter calculator for an exposure index of 50, which applies to a 5-second exposure. Calculate a tentative exposure time for the desired lens opening. If this time is much shorter or longer than 5 seconds, select the applicable exposure index from the following:

1/50 to 1/5 second, ASA 80, no filter	
1 second, ASA 64, no filter	30 seconds, ASA 32, CC10Y
5 seconds, ASA 50, no filter	60 seconds, ASA 25, CC20Y

8. See supplementary data on instruction sheet packaged with this film.

5

When the camera lens is extended to focus on a subject closer than 8 times its focal length, as is usual in copying, exposure computation must allow for the change in effective f-number.

LENS EXTENSION EXPOSURE FACTORS FOR 35MM CAMERAS

Since lens extension correction depends on reduction or magnification, it can be found for a given film size by measuring the length of a subject area that will fill the length of the film area. The table below assumes focusing is done by extending the lens, not by using supplementary lenses. The table applies to full-frame 35mm (24 x 36mm) and 828 (28 x 40mm) films. If the resulting exposure time exceeds that for which the film is designed, the exposure adjustment required by reciprocity effect, described below, must also be considered.

LENS EXTENSION EXPOSURE FACTORS FOR FULL-FRAME 35mm CLOSE-UPS										
Length of Subject	11	5⅛	3¼	2¼	2	1⅜	1	¾	½	inches
Open Lens by	⅓	⅔	1	1⅓	1½	2	2½	3	4	stops
or Multiply Time by	1.3	1.6	2	2.5	2.8	4	5.7	8	16	

LENS EXTENSION EXPOSURE FACTORS FOR VIEW CAMERAS

1. Find the exposure time by using an exposure meter. Set the appropriate exposure index from pages 2 through 5.
2. Find the lens extension exposure factor (number by which the meter-indicated exposure time must be multiplied to allow for lens extension in close-ups). To determine this factor, put a card 2 inches long at the subject and, with the scale provided at the side of this page, measure the image of the card on the ground glass. That is, line up the arrow on the scale with one end of the image of the card; read the lens extension exposure factor at the other end of the image.
3. Multiply the exposure time by the appropriate lens extension exposure factor *or* open the lens by the number of stops shown. If the exposure time exceeds 1 second, reciprocity effect must be considered.

RECIPROCITY EFFECT

Reciprocity effect becomes a factor whenever exposure times longer than those for which the film is designed are to be used and if these times have been determined by an exposure-meter calculation in which the exposure index set on the meter did not compensate for effective speeds at long exposure times.

The tables on page 7 give exposure times corrected for reciprocity effect alone, as well as lens extension exposure factors combined with reciprocity effect, for the two color sheet films most commonly used at long exposure times: KODAK EKTACHROME Film 6116, Type B (Process E-3) and KODAK EKTACOLOR Professional Film 6102, Type L.

The table on page 5 gives exposure compensations for the reciprocity characteristics of the Kodak color films. In addition, the table indicates the filter compensations, if any, that are necessary to retain a normal color balance. The data in the table on page 5 apply only to the type of illumination for which each specific film is balanced, and the figures are based on average emulsions.

2 INCHES

stops
10.0X
3 · 8.0
2⅔ · 6.3
2⅓ · 5.0
2 · 4.0
1⅔ · 3.2
1⅓ · 2.5
1 · 2.0
⅔ · 1.6
⅓ · 1.3

Lens Extension Exposure Factors and Reciprocity Effect Table for KODAK EKTACHROME Film, Type B (Process E-3)[1]

Uncorrected Exposure Time[2]	Exposure Time Adjusted for Reciprocity Effect	Exposure Time Adjusted for Reciprocity Effect and Lens Extension Exposure Factors									
		1.3	1.6	2.0	2.5	3.2	4.0	5.0	6.3	8.0	10.0
1"	1"	1.3"	1.6"	2.2"	2.8"	3.6"	5"	7"	8"	12"	16"
1.2"	1.2"	1.6"	2.2"	2.8"	3.6"	5"	7"	8"	12"	16"	19"
1.6"	1.6"	2.2"	2.8"	3.6"	5"	7"	8"	12"	16"	19"	27"
2"	2.2"	2.8"	3.6"	5"	7"	8"	12"	16"	19"	27"	36"
2.5"	2.8"	3.6"	5"	7"	8"	12"	16"	19"	27"	36"	48"
3.2"	3.6"	5"	7"	8"	12"	16"	19"	27"	36"	48"	1'7"
4"	5"	7"	8"	12"	16"	19"	27"	36"	48"	1'7"	1'28"
5"	7"	8"	12"	16"	19"	27"	36"	48"	1'7"	1'28"	1'55"
6.4"	8"	12"	16"	19"	27"	36"	48"	1'7"	1'28"	1'55"	2'27"
8"	12"	16"	19"	27"	36"	48"	1'7"	1'28"	1'55"	2'27"	3'36"
10"	16"	19"	27"	36"	48"	1'7"	1'28"	1'55"	2'27"	3'36"	4'50"
12"	19"	27"	36"	48"	1'7"	1'28"	1'55"	2'27"	3'36"	4'50"	6'
16"	27"	36"	48"	1'7"	1'28"	1'55"	2'27"	3'36"	4'50"	6'	9'
20"	36"	48"	1'7"	1'28"	1'55"	2'27"	3'36"	4'50"	6'	9'	13'
25"	48"	1'7"	1'28"	1'55"	2'27"	3'36"	4'50"	6'	9'	13'	16'
32"	1'7"	1'28"	1'55"	2'27"	3'36"	4'50"	6'	9'	13'	16'	
40"	1'28"	1'55"	2'27"	3'36"	4'50"	6'	9'	13'	16'		
50"	1'55"	2'27"	3'36"	4'50"	6'	9'	13'	16'			
60"	2'27"	3'36"	4'50"	6'	9'	13'	16'				
1'20"	3'36"	4'50"	6'	9'	13'	16'					
1'40"	4'50"	6'	9'	13'	16'						
2'	6'	9'	13'	16'							
2'40"	9'	13'	16'								
3'20"	13'	16'									
4'	16'										

" = sec ' = min

Exposures longer than 30 seconds may result in color reproduction errors that cannot be corrected satisfactorily by any selection of taking filters.

[1] Exposure times given include the exposure increase required by using the filters recommended on the data sheet packaged with the film.
[2] Times given assume that the speed set on the exposure meter is the speed recommendation for a ½-second exposure (32 for average emulsions) imprinted on the data sheet packaged with the film. The light source is 3200 K studio lamps.

Lens Extension Exposure Factors and Reciprocity Effect Table for KODAK EKTACOLOR Professional Film, Type L

Uncorrected Exposure Time* (In Seconds)	Exposure Time Adjusted for Reciprocity Effect	Exposure Time (In Seconds) Adjusted for Reciprocity Effect and Lens Extension Exposure Factors									
		1.3	1.6	2.0	2.5	3.2	4.0	5.0	6.3	8.0	10.0
1	1.3	1.7	2.2	2.9	3.8	5	6.7	9	12	16	22
1.2	1.6	2.2	2.9	3.8	5	6.7	9	12	16	22	30
1.6	2.2	2.9	3.8	5	6.7	9	12	16	22	30	45
2	2.9	3.8	5	6.7	9	12	16	22	30	45	65
2.5	3.8	5	6.7	9	12	16	22	30	45	65	
3.2	5	6.7	9	12	16	22	30	45	65		
4	6.7	9	12	16	22	30	45	65			
5	9	12	16	22	30	45	65				
6.4	12	16	22	30	45	65					
8	16	22	30	45	65						
10	22	30	45	65							
12	30	45	65								
16	45	65									
20	65										

If the film is exposed for times longer than 60 seconds, the resulting negatives may contain color-reproduction errors that cannot be corrected satisfactorily in the printing operation.

*Times given assume that an exposure index of 80 for a 3200 K lamp source is set on the exposure meter.

The series of KODAK WRATTEN Filters known as KODAK Light Balancing Filters can be used to change the color quality of the exposing light in order to secure proper color balance with artificial-light films.

			Color Temperature of Source		
Color	Filter Number	Exposure Increase in Stops*	Converted to 3200 K	Converted to 3400 K	Mired Interval
KODAK Light Balancing Filters					
Bluish	82C + 82C	1⅓	2490 K	2610 K	−89
	82C + 82B	1⅓	2570 K	2700 K	−77
	82C + 82A	1	2650 K	2780 K	−65
	82C + 82	1	2720 K	2870 K	−55
	82C	⅔	2800 K	2950 K	−45
	82B	⅔	2900 K	3060 K	−32
	82A	⅓	3000 K	3180 K	−21
	82	⅓	3100 K	3290 K	−10
No Filter Necessary			3200 K	3400 K	−
Yellowish	81	⅓	3300 K	3510 K	9
	81A	⅓	3400 K	3630 K	18
	81B	⅓	3500 K	3740 K	27
	81C	⅓	3600 K	3850 K	35
	81D	⅔	3700 K	3970 K	42
	81EF	⅔	3850 K	4140 K	52

The KODAK Color Compensating Filters listed below are used to make changes in the overall color balance of photographic results obtained with color films and to compensate for deficiencies in the quality of the light by which color films must sometimes be exposed. Over camera and enlarger lenses, they can be used singly, or in combinations of no more than three filters, to introduce almost any desired correction.

KODAK Color Compensating Filters						
Peak Density	Yellow (Absorbs Blue)	Exposure Increase in Stops*	Magenta (Absorbs Green)	Exposure Increase in Stops*	Cyan‡ (Absorbs Red)	Exposure Increase in Stops*
.025	CC025Y	−	CC025M	−	CC025C	−
.05	CC05Y†	−	CC05M†	⅓	CC05C†	⅓
.10	CC10Y†	⅓	CC10M†	⅓	CC10C†	⅓
.20	CC20Y†	⅓	CC20M†	⅓	CC20C†	⅓
.30	CC30Y	⅓	CC30M	⅔	CC30C	⅔
.40	CC40Y†	⅓	CC40M†	⅔	CC40C†	⅔
.50	CC50Y	⅔	CC50M	⅔	CC50C	1
Peak Density	Red (Absorbs Blue and Green)	Exposure Increase in Stops*	Green (Absorbs Blue and Red)	Exposure Increase in Stops*	Blue (Absorbs Red and Green)	Exposure Increase in Stops*
.025	CC025R	−	−	−	−	−
.05	CC05R†	⅓	CC05G	⅓	CC05B	⅓
.10	CC10R†	⅓	CC10G	⅓	CC10B	⅓
.20	CC20R†	⅓	CC20G	⅓	CC20B	⅔
.30	CC30R	⅔	CC30G	⅔	CC30B	⅔
.40	CC40R†	⅔	CC40G	⅔	CC40B	1
.50	CC50R	1	CC50G	1	CC50B	1⅓

*These values are approximate. For critical work, they should be checked by practical test, especially if more than one filter is used.
†Similar KODAK Color Printing Filters (Acetate) are available. They should be used only between the light source and the negative.
‡Another series of cyan color-compensating filters, designated with the suffix "−2," is recommended for use in EKTACOLOR and EKTACHROME Paper printing filter packs.